MAYNARD AND ZANE

Together at Last

A Tribute to Two Icons of the Old West

Compiled by Ed Meyer

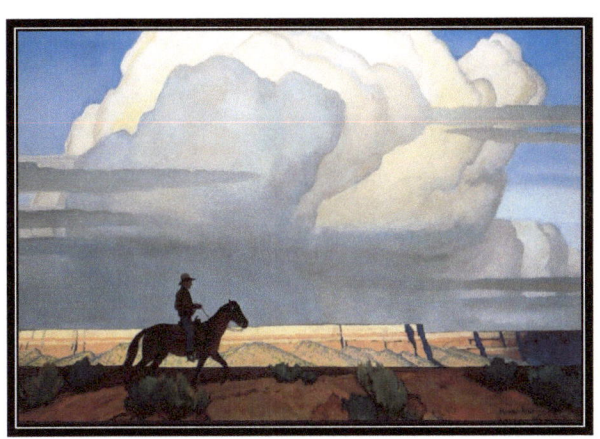

Maynard Dixon

Copyright © 2012 Ed Meyer

All rights reserved.

ISBN-13: 978-1533274304
ISBN-10: 1533274304

DEDICATION

Maynard and Zane: Together At Last is dedicated to fans around the world who have enjoyed Maynard Dixon's art and Zane Grey's western romance novels for so many years. It is also dedicated to a new generation of fans who will someday be inspired by these two great men.

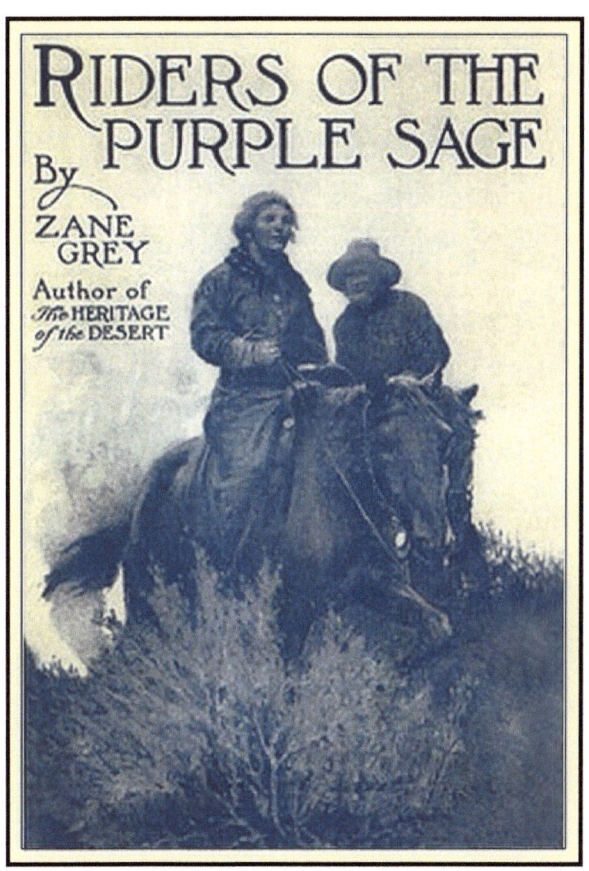

CONTENTS

Preface

Wilderness Odyssey 9

Mustangs 10

The Navajo 11

Eagles 12

The Desert 13

Journey's End 14

Open Range 15

The Grand Canyon 16

Remote Outposts 17

Alone in the Wild 18

Maynard's Cowboys 19

About Maynard Dixon 20

About Zane Grey 22

Zane Grey's Westerns 25

Walking in Maynard's and Zane's Footprints 26

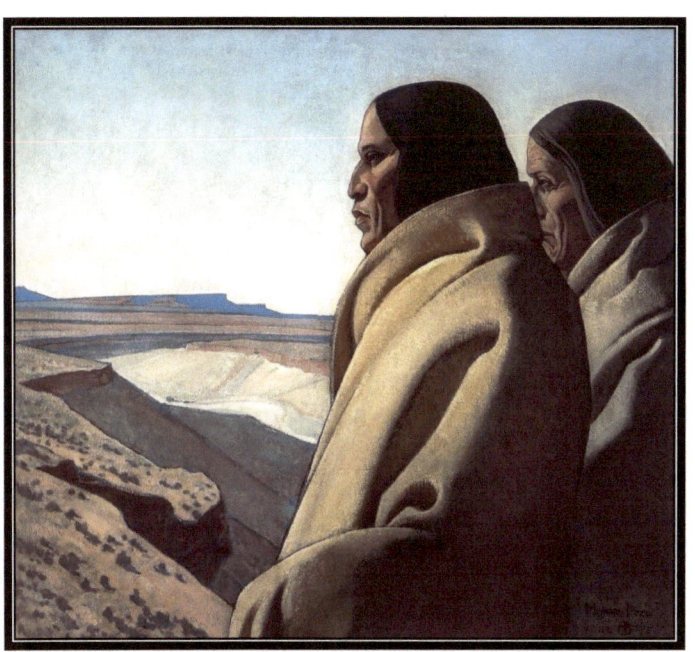

Men of the Red Earth: Maynard Dixon

PREFACE

A good case can be made that Zane Grey's fifty-eight western romance novels, including *Riders of the Purple Sage*, and Maynard Dixon's hundreds of western paintings and illustrations created the world's vision of the Old West. Though both men are long gone, thousands of words have been written, easels painted and movies filmed by individuals inspired by Grey and Dixon.

It is surprising the two men didn't cross paths on some lonely desert and high canyon wall at some point in their lives, but there is no record of such a meeting. Certainly, they visited many of the same places and interacted with people both knew well. They even shared a common connection in the rugged landscape along the Utah-Arizona border.

Though Grey (1872) and Dixon (1875) were close in age, their journeys to the highlands north of the Grand Canyon took very different courses. Zane Grey came early in his career. In 1907 and 1908, the aspiring author gained the inspiration for his first novels on a trip west with "Buffalo Jones" to film the old plainsman roping mountain lions on the North Rim of the Grand Canyon. Through the years, the author returned both to do research for new novels and film movies based on his works.

Maynard Dixon's days along the Utah-Arizona border became later in life. He first visited Zion Canyon and Kane County's tiny hamlet of Mt. Carmel in 1933 with his first wife, famous photographer Dorothea Lange. He returned in 1935 with his second wife, muralist Edith Hamblin, and eventually built a retreat in Mt. Carmel. Many of Dixon's most powerful works were painted in Southern Utah.

Though these giants of literature and art individually branded images of the Old West in the minds of people everywhere, one might wonder how much more powerful their works would have been had they met and collaborated. *Maynard and Zane: Together at Last* brings these two great minds together for the first time to address a few common theme

WILDERNESS ODYSSEY

Hare rose presently and, laboring into the wagon, lay down on the sacks. Familiar lumbering of wheels began, and the clanking of the wagon-chain. Despite jar and jolt he dozed at times, awakening to the scrape of the wheel on the leathern brake. After a while the rapid descent of the

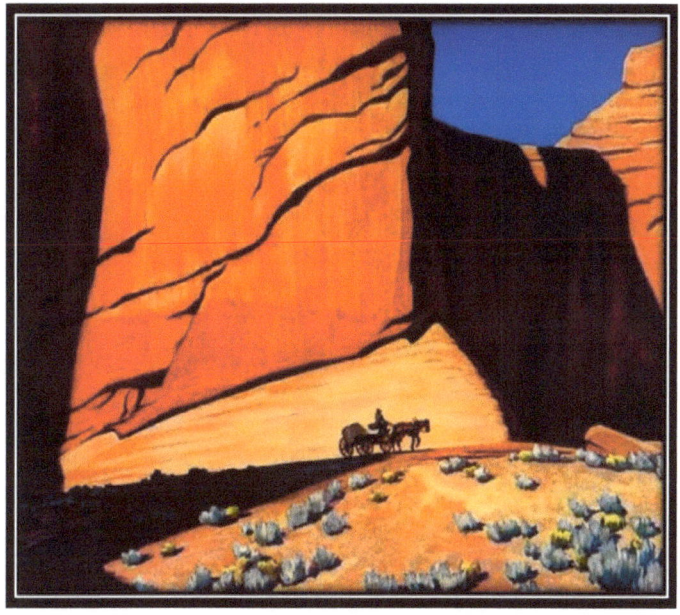

To the Desert Again: Maynard Dixon

wagon changed to a roll, without the irritating rattle. He saw a narrow valley; on one side the green, slow-swelling cedar slope of the mountain; on the other the perpendicular red wall. Beyond lay something vast and illimitable, a far-reaching vision of white wastes, of purple plains, of low mesas lost in distance. By and by there came a halt, the din of stamping horses and sharp commands, the bustle and confusion of camp.

Heritage of the Desert
Zane Grey

MUSTANGS

With long manes and tails flying, the mustangs came on apace and passed us in a trampling roar, the white stallion in the front. Suddenly a shrill, whistling blast, unlike any sound I had ever heard, made the canyon fairly ring. The white stallion plunged back, and his band closed i

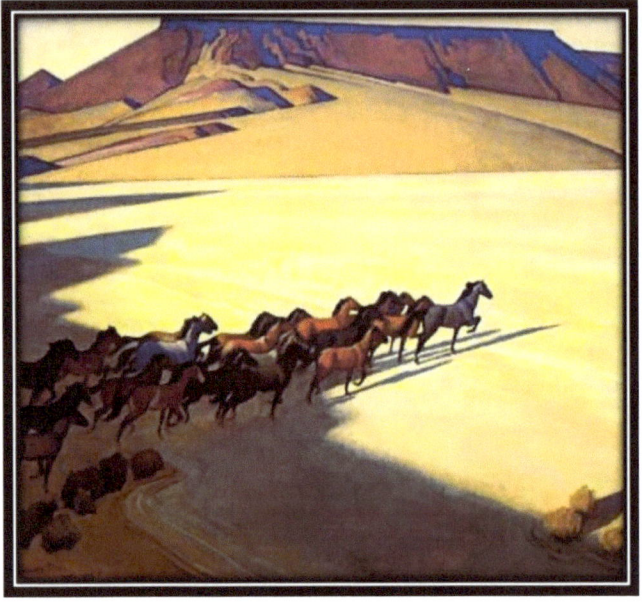

Mustangs: Maynard Dixon

The white stallion plunged back, and his band closed in behind him. He had seen our saddle horses. Then trembling, whinnying, and with arched neck and high- poised head, bespeaking his mettle, he advanced a few paces, and again whistled his shrill note of defiance.

Then followed confusion for me. The pound of hoofs, the snorts, a screaming neigh that was frightful, the mad stampede of the mustangs with a whirling cloud of dust. A mass of tossing manes, foam-flecked black horses, wild eyes and lifting hoofs rushed at me. My eyes were blinded by dust; the smell of dust choked me. Then they had passed, on the wings of the dust-laden breeze.

The Last of the Plainsmen
Zane Grey

THE NAVAJO

It was as if he saw the desert with new eyes. All the old landmarks appeared magnified. The walls and pyramids that for hundreds of years had been invested with the spirits of his race seemed glorified in his sight, yet they were not idols or gods to kneel before and worship. Through them his senses grasped at a different meaning of beauty and nature, time and life.

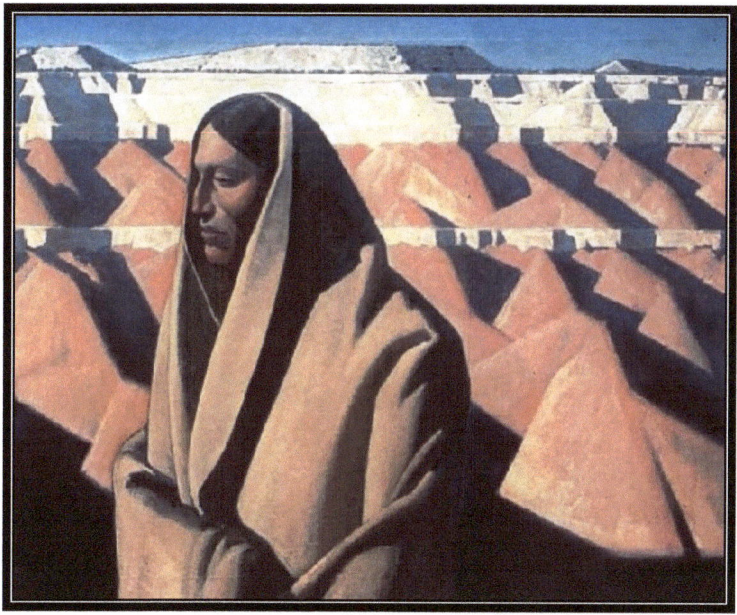

Earth Knower. Maynard Dixon

The shadows under the mounting walls now showed black and again silver. The star-fired stream of blue sky above narrowed between the black rims, farther and higher as he rode down and down into the silent bowels of the rock-ribbed earth. For Nophaie it spelled freedom. Its isolation and loneliness and solitude meant for him the uttermost peace. There dawned upon Nophaie the glory of nature. Just so long as he could stay there he would be free.

The Vanishing American
Zane Grey

EAGLES

High upon the western rampart of that valley perched an eagle, watching from his lonely crag. Wild, primitive, grand was the scene. The future stretched away like the dim, strange, unknown purple distances, with an intimation of tragedy. But the hour was one of natural fruition, with the sun like an eye of the Creator, shining over the land. Peace, silence, solitude attended the eagle in his vigil.

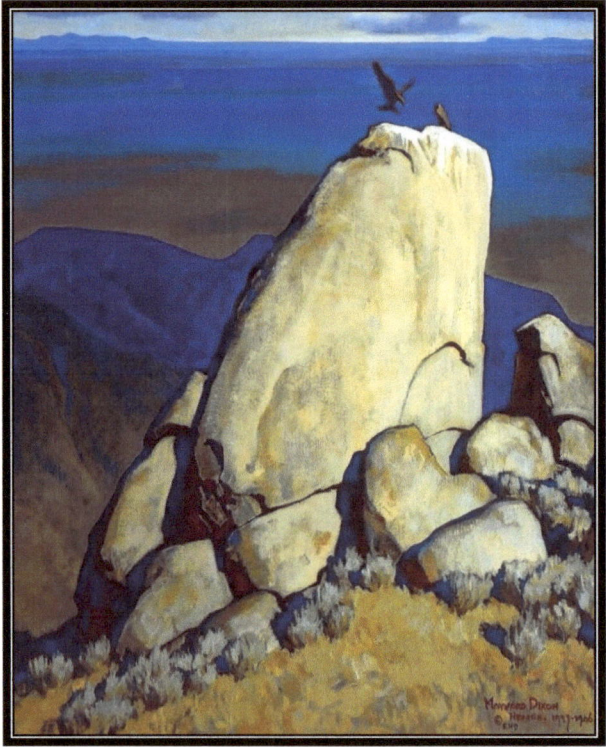

Eagle's Roost: Maynard Dixon

Yet a brooding sadness, like an invisible mantle, lay over the valley. Was it the pervading spirit of a dying season? Life was sweet, scented on the wind, but there was death lurking somewhere, perhaps in the purple shadow of distance to the southward. The morning was bright, golden, glorious, yet it did not wait, and night was coming.

The Thundering Herd
Zane Grey

THE DESERT

A deepening rose color over the eastern horizon appeared to be reflected upon the mountain peaks, and this glow crept down the dark slopes. Grey dawn changed to radiant morning with an ethereal softness of color. When the blazing disc of the sun shone over the ramparts of the east all that desert world underwent a wondrous transfiguration.

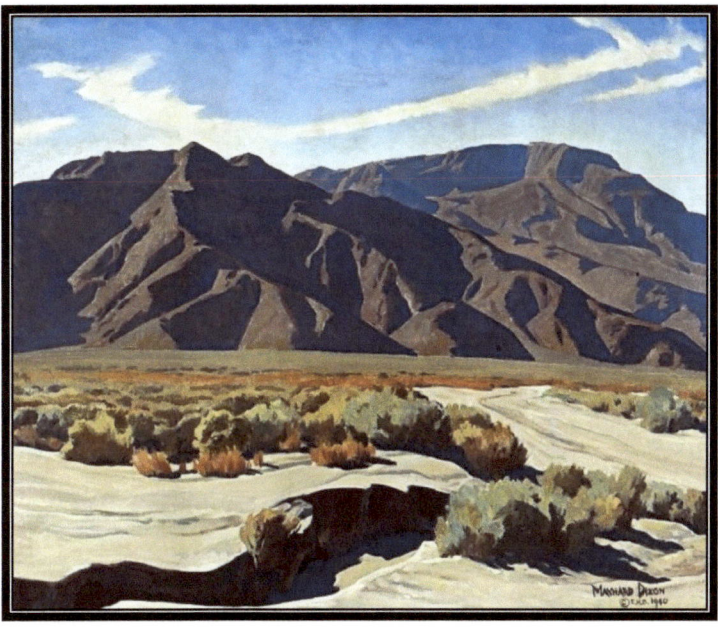

Desert Ranges: Maynard Dixon

As he climbed he gazed up into the coppery sky, but his hot and tired eyes could not endure the great white blaze that was the sun. Halfway up he halted to rest, and from here he had measureless view of the desert. Then his dull brain revived to a final shock. For he seemed to see a thousand miles of green-grey barrenness, of lifting heat veils like transparent smoke, of wastes of waved sand, and of ranges of upheaved rock. How terribly it confronted him! Pitiless mockery of false distances on all sides A sun-blasted world not meant for man!

Wanderer of the Desert
Zane Grey

JOURNEY'S END

At noon the cavalcade crossed the divide between two of the huge sage hills and found easier travel downward. A breeze swept up from the vast gray-and-black basin. The slope was long, rolling, somehow beautiful despite the aridity. At a distance, the sage appeared softly gray, merging into purple.

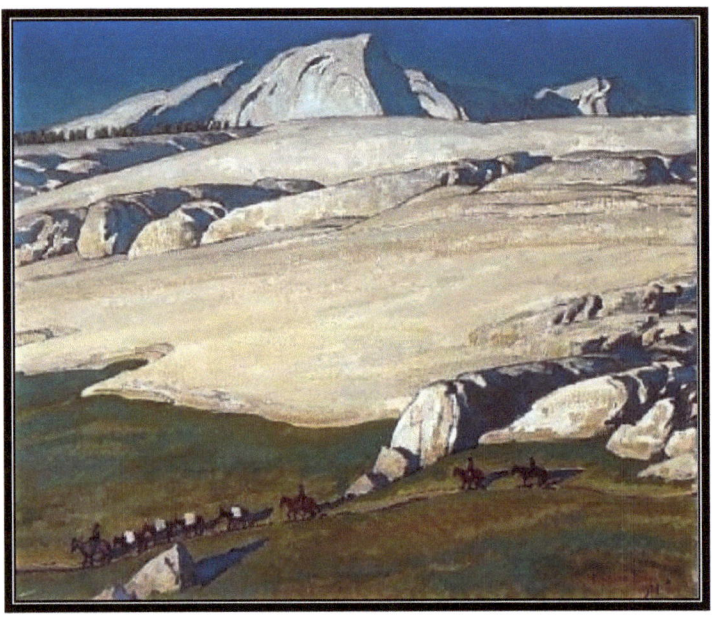

Moraine and meadow, Sierra Nevada, Inyo County, California:
Maynard Dixon

A cowboy called Marvie's attention to black and white dots on the far high slope. Wild horses! How Ina thrilled to the words and the sight! Yet this feeling was slight to that which gripped her when Marvie pointed across the great open space of land and water to a winding pale ribbon--Forlorn River.

Forlorn River
Zane Grey

OPEN RANGE

Wade thought it the wildest and loveliest spot in the world. A belt of luxuriant grass sloped for a few miles down to the bleached range of safe and yucca; and this belt held ten thousand head of steers, cows, yearlings, calves, all jingle-bobbed and as fat as butter. The herd required little guarding because they would not leave that zone of pure water and rich grass.

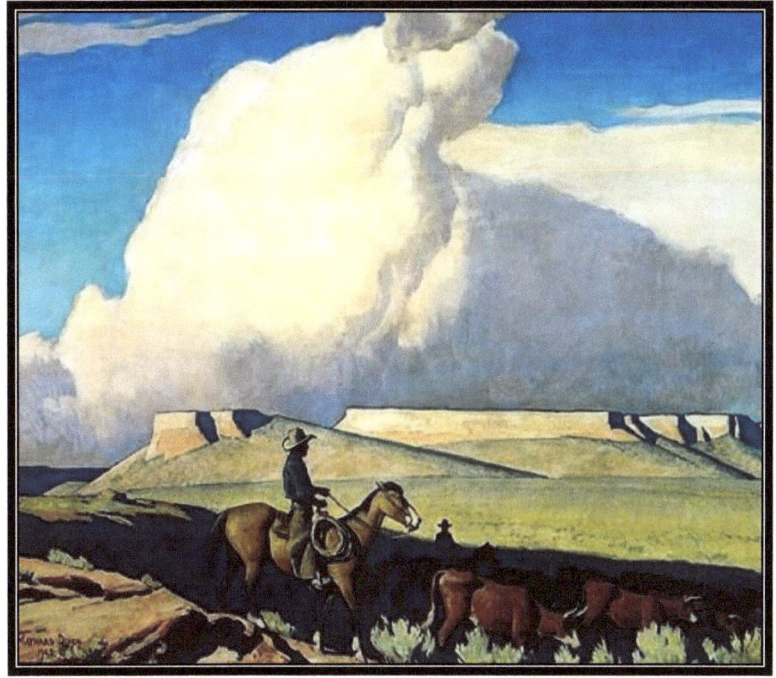

Open Range: Maynard Dixon

Whenever Wade looked down this slope his gaze encountered the grazing cattle, and the scene filled his heart with delight. He had found his place. A cowboy of the range until he could earn a herd!

Shadow on the Trail
Zane Grey

THE GRAND CANYON

Down, down, down, we went, till the yellow rim above seemed a thin band of gold. I saw that we were almost to the canyon proper, and I wondered what would happen when we reached it. The dark shaded watercourse suddenly shot out into bright light and ended in a deep cove, with perpendicular walls fifty feet high. I could see where a few rods farther on this cove opened into a huge, airy, colored canyon.

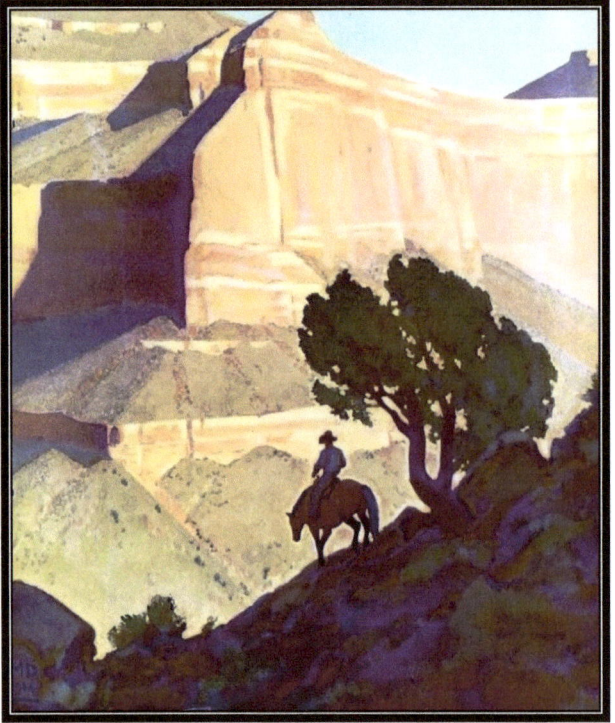

Untitled: Maynard Dixon

Almost before I knew what I was about, I stood gasping on the gigantic second wall of the canyon, with nothing but thin air under me, except, far below, faint and indistinct purple clefts, red ridges, dotted slopes, running down to merge in a dark, winding strip of water, that was the Rio Colorado. A sullen murmur soared out of the abyss.

Tales of Lonely Trails
Zane Grey

REMOTE OUTPOSTS

Shefford halted his tired horse and gazed with slowly realizing eyes. A league-long slope of sage rolled and billowed down to Red Lake, a dry red basin, denuded and glistening, a hollow in the desert, a lonely and desolate door to the vast, wild, and broken upland beyond. Red Lake must be his Rubicon. Either he must enter the unknown to seek, to strive, to find, or turn back and fail and never know and be always haunted.

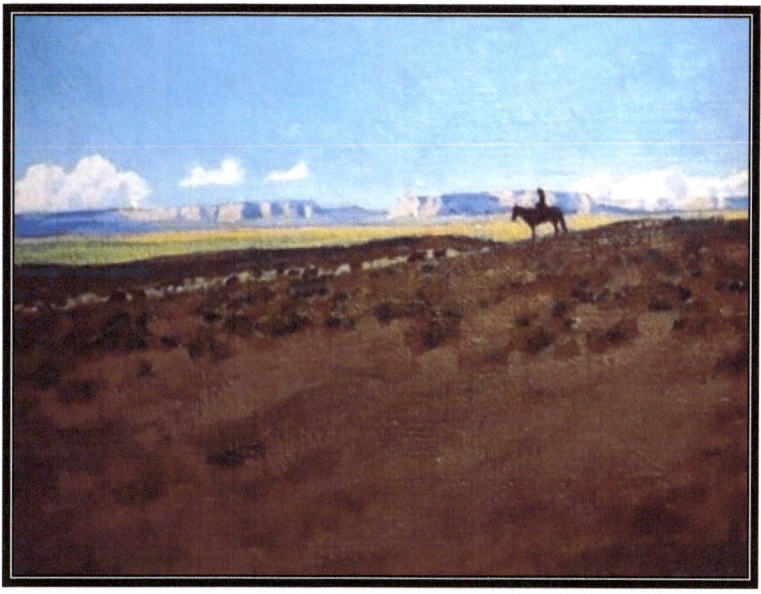

Shepherd Boy, Red Lake, Arizona: Maynard Dixon

As if impelled Shefford started his horse down the sandy trail. Long shadows crept down the slope ahead of him and the scant sage deepened its gray. He watched the lizards shoot like brown streaks across the sand, leaving their slender tracks; he heard the rustle of pack-rats as they darted into their brushy homes; the whir of a low-sailing hawk startled his horse.

The Rainbow Trail
Zane Grey

ALONE IN THE WILD

Jean almost crossed a well-beaten trail, leading through a pine thicket and down over the Rim. Jean's pack mule led the way without being driven. That trail was steep, narrow, clogged with stones, and as full of sharp corners as a crosscut saw. Once on the descent with a packed mule, Jean had no time for mind wanderings and very little for occasional glimpses out over the cedar tops to the vast blue hollow asleep under a westering sun.

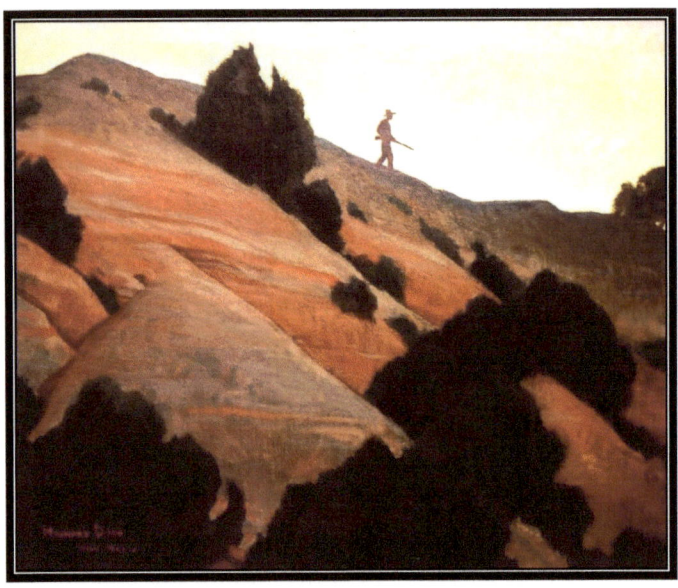

Hogback Hill: Maynard Dixon

The stones rattled, the dust rose, the cedar twigs snapped, the little avalanches of red earth slid down, the iron-shod hoofs rang on the rocks. This slope widened in fan shape as Jean descended. He zigzagged down a thousand feet before the slope benched into dividing ridges. Here the cedars and junipers failed and pines once more hid the sun. Deep ravines were black with brush. From somewhere rose a roar of running water, most pleasant to Jean's ears. Fresh deer and bear tracks covered old ones made in the trail.

To the Last Man
ZANE GREY

MAYNARD'S COWBOYS

Maynard Dixon is best known for his iconic western landscapes, but he also provided illustrations for western novels, advertisements and magazines. A few of Dixon's cowboys were featured earlier in this tribute, but any fan of western art and writings will enjoy seeing a few more of Maynard's cowboys as, of course, would Zane Grey.

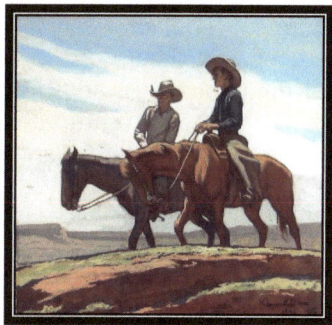
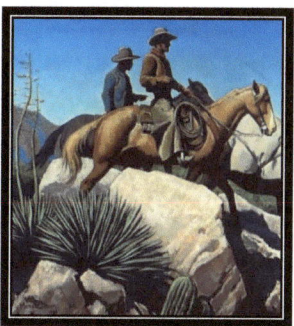

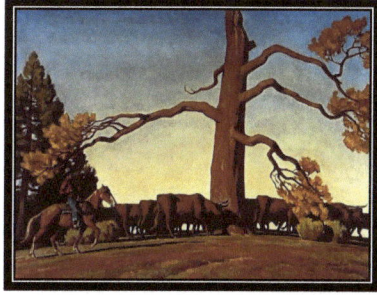
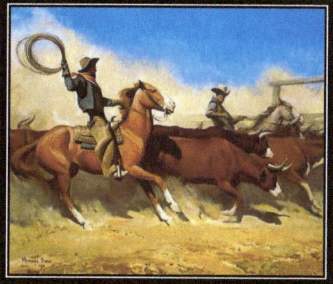

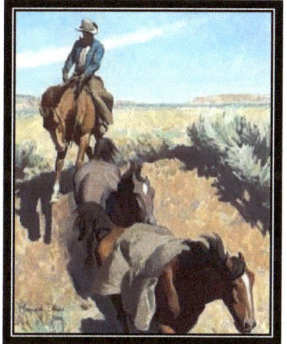
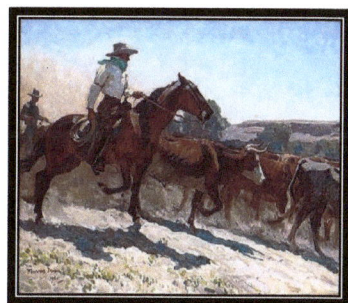

ABOUT MAYNARD DIXON (1875-1946)

Dixon was born in Fresno, California, into a family of aristocratic Virginia Confederates who had found a new home there after the American Civil War. His mother, Constance Maynard, a well-educated daughter of a Navy officer from San Francisco, shared her love of classic literature with the young boy and encouraged him in his writing and drawing. His father was Harry St. John Dixon. Dixon later studied briefly with the tonalist painter Arthur Mathews at the California School of Design where he became close friends with Xavier Martinez and others of the Bohemian Club. To support himself he accepted numerous illustration jobs. Great illustrators were plentiful around the turn of the century, yet Dixon obtained work from the Overland Monthly and several San Francisco newspapers.

In 1900 Dixon visited Arizona and New Mexico. This was the start of his lifelong passion for roaming the West. The next year he accompanied artist Edward Borein on a horseback trip through several Western states. In California, he illustrated books and magazines with Western themes. Some of his most memorable work from these early years appeared in Clarence Mulford's books about Hopalong Cassidy. For a time he lived in New York with his young wife and baby daughter Constance, but soon returned to the western United States where he said he could create "honest art of the west" instead of the romanticized versions he was being paid to create. Shortly after he began a new life in San Francisco, his first marriage ended.

Dixon developed his style during this early period, and Western themes became a trademark for him. In San Francisco, Dixon was considered a colorful character with a good sense of humor. He often dressed like a cowboy and seemed determined to impart a Western style, most often in the form of a black Stetson, boots and a bola tie.

Influenced in part by the Panama Pacific International Exposition of 1915, Dixon began to search for a new expression, moving away from impressionism and into a simpler, more modern style. Meeting and marrying Dorothea Lange, a portrait photographer from the East, had a great influence on his art. They married in 1920 and by 1925, the year their first son Daniel Rhoades Dixon was born, Maynard's style had changed dramatically to even more powerful compositions, with the emphasis on design, color, and self-expression. A true modernist emerged. The power of low horizons and marching cloud formations, simplified and distilled, became his own brand and at once were both

Maynard and Zane: Together at Last

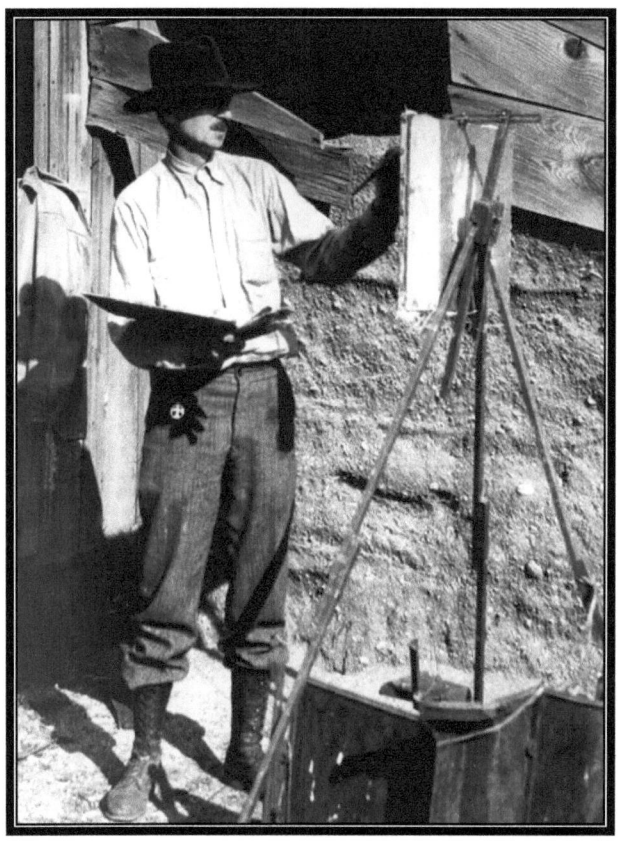

bold and mysterious. In 1929 his second son was born, John Eaglefeather Dixon. During the Great Depression, Dixon painted a series of social realism canvases depicting the prevailing politics of maritime strikes, displaced workers, and those affected by the depression. Simultaneously, Lange captured on film images of the migrant workers in the Salinas Valley and the city breadlines, images that eventually brought her fame. In 1933 the Dixons spent the summer in Zion National Park with sojourns to the hamlet of Mount Carmel, Utah. Lange was called back to San Francisco, a separation which led to the couple's divorce in 1935.

Two years later, Dixon married San Francisco muralist Edith Hamlin. The couple left San Francisco two years later for southern Utah, the source of some of Dixon's greatest art. In 1939, the couple built a summer home in the tiny Mormon community of Mount Carmel, Utah where he was reacquainted with the local natural landscapes. He lived near the cottonwood trees along an old irrigation ditch and took short hikes to a plateau where he loved the quiet. Dixon spent winter months in Tucson, where the couple also had a home and studio.

Dixon continued to create simple but powerful compositions in which non-essential elements were distilled or eliminated. In 1946, Maynard died at his winter home in Tucson. In the spring of 1947, his widow Edith brought his ashes to Mount Carmel where she buried them on a high bluff above the art studio being built on the property. This had been at his request and she felt it a fitting tribute where friends could come to pay respects and view the land that he loved.

ABOUT ZANE GREY (1872-1939)

Pearl Zane Grey was born January 31, 1872, in Zanesville, Ohio. He was the fourth of five children born to Alice "Allie" Josephine Zane, whose English Quaker immigrant ancestor Robert Zane came to the North American colonies in 1673, and her husband, Lewis M. Gray, a dentist. He grew up in Zanesville, a city founded by his maternal great-grandfather Ebenezer Zane, an American Revolutionary War patriot.

Grey chose the University of Pennsylvania on a baseball scholarship, where he studied dentistry and joined Sigma Nu fraternity; he graduated in 1896.

After graduating, Grey established his practice in New York City under the name of Dr. Zane Grey in 1896. It was a competitive area but he wanted to be close to publishers. He began to write in the evening to offset the tedium of his dental practice. He struggled financially and emotionally. Grey was a natural writer but his early efforts were stiff and grammatically weak. Whenever possible, he played baseball with the Orange Athletic Club in New Jersey, a team of former collegiate players that was one of the best amateur teams in the country.

Grey often went camping with his brother R.C. in Lackawaxen, Pennsylvania, where they fished in the upper Delaware River. When canoeing in 1900, Grey met seventeen-year-old Lina Roth, better known as "Dolly". Dolly came from a family of physicians and was studying to be a schoolteacher. After a passionate and intense courtship marked by frequent quarrels, Grey and Dolly married five years later in 1905

After they married in 1905, Dolly gave up her teaching career. They moved to a farmhouse at the confluence of the Lackawaxen and Delaware rivers, in Lackawaxen, Pennsylvania, where Grey's mother and sister joined them. Grey finally ceased his dental practice to devote full-time to his nascent literary pursuits. Dolly's inheritance provided an initial financial cushion.

While Dolly managed Grey's career and raised their three children over the next two decades Grey often spent months away from the family. Throughout their life together, he highly valued her management of his career and their family, and her solid emotional support. In addition to her considerable editorial skills, she had good business sense and

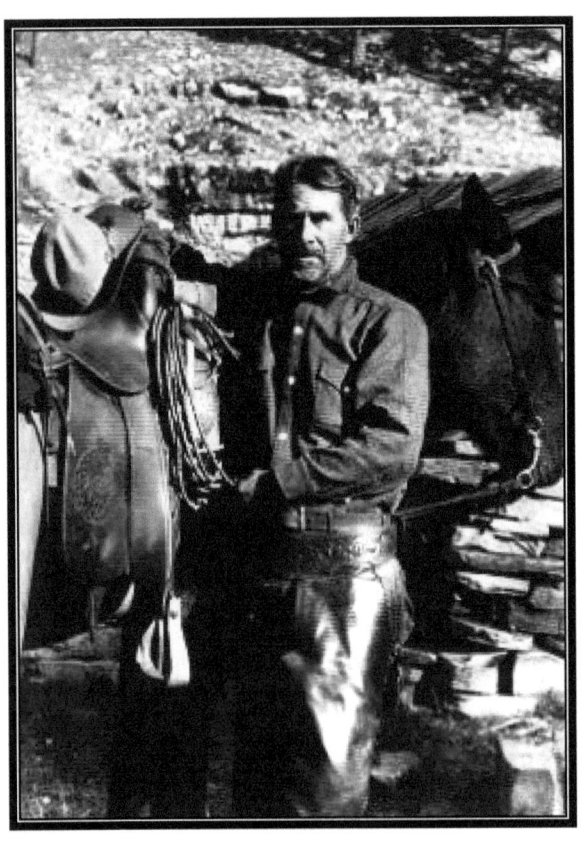

handled all his contract negotiations with publishers, agents, and movie studios. All his income was split fifty-fifty with her; from her "share", she covered all family expenses. Their considerable correspondence shows evidence of his lasting love for her despite his infidelities and personal emotional turmoil.

The Greys moved to California in 1918. In 1920 they settled in Altadena, California, where Grey bought a prominent mansion on East Mariposa Street, known locally as "Millionaire's Row".

With the help of Dolly's proofreading and copy editing, Grey gradually improved his writing. His first magazine article, "A Day on the Delaware", a human-interest story about a Grey brothers' fishing expedition, was published in the May 1902 issue of *Recreation* magazine. Elated by selling the article, Grey offered reprints to patients in his waiting room.

After attending a lecture in New York in 1907 by Charles Jesse "Buffalo" Jones, western hunter and guide, Grey arranged for a mountain lion-hunting trip to the North Rim of the Grand Canyon. He brought along a camera to document his trips and prove his adventures. His first two trips were arduous, but Grey learned much from his compatriot adventurers. He gained the confidence to write convincingly about the American West, its characters, and its landscape. Treacherous river crossings, unpredictable beasts, bone-chilling cold, searing heat, parching thirst, bad water, irascible tempers, and heroic cooperation all became real to him. Upon returning home in 1909, Grey wrote a new novel, *The Last of the Plainsmen*, describing the adventures of Buffalo Jones.

With the birth of his first child pending, Grey felt compelled to complete his next novel, *The Heritage of the Desert*. He wrote it in four months in 1910. It quickly became a bestseller. Two years later Grey produced his best-known book, *Riders of the Purple Sage* (1912), his all-time best-seller, and one of the most successful Western novels of all.[1]

Over the years, Grey spent part of his time traveling and the rest of the year wrote novels and articles. Unlike writers who could write every day, Grey would have dry spells and then sudden bursts of energy, in which he could write as much as 100,000 words in a month.

During the 1930s, Grey continued to write, but the Great Depression hurt the publishing industry. His sales fell off, and he found it more difficult to sell serializations. He had avoided making investments that would have been affected by the stock market crash of 1929, and continued to earn royalty income, so he did better than many financially. Nearly half of the film adaptations of his novels were made in the 1930s.

Acknowledgement: Historic information about Maynard Dixon and Zane Grey is provided courtesy of Wikipedia Creative Commons attribution- Share-Alike 3.0 License.

For more information about Zane Grey, visited the Zane Grey's West Society website at http://zgws.org.

ZANE GREY'S WESTERNS
(Listed by Original Title)

Arizona Ames
The Black Mesa
Border Legion
Call of the Canyon
Captives of the Desert
Day of the Beast
Desert Gold
Don - the Story of a Dog
Dude Ranger
Fugitive Trail
Heritage of the Desert
Knights of the Range
Light of Western Stars
Lost Pueblo
Majesty's Rancho
Maverick Queen
Nevada
Raiders of Spanish Peaks
Robber's Roost
Rogue River Feud
Shepherd of Guadaloupe
Stairs of Sand
Tappan's Burro
Thunder Mountain
To the Last Man
Twin Sombreros
U.P. Trail
Vanishing American
West of the Pecos
Wildfire
Wolf Tracker

Arizona Clan
Blue Feather
Boulder Dam
Camp Robber
Code of the West
Deer Stalker
Desert of Wheat
Drift Fence
Forlorn River
Hash Knife Outfit
Horse Heaven Hill
Last of the Plainsmen
Lone Star Ranger
Lost Wagon Train
Man of the Forest
Mysterious Rider
Rainbow Trail,
Ranger & Other Stories
Riders of the Purple Sage
Shadow on the Trail
Stranger from the Tonto
Sunset Pass
30,000 on the Hoof
The Thundering Herd
Trail Driver
Under the Tonto Rim
Valley of Wild Horses
Wanderer of the Wasteland
Western Union
Wild Horse Mesa
Wyoming

WALKING IN MAYNARD'S AND ZANE'S FOOTPRINTS

Though Maynard Dixon and Zane Grey have been gone now for more than seventy-five years, there are still places along the Utah-Arizona border where you can visit and still feel their presence.

Maynard Dixon Home and Studio
Mt. Carmel, Utah

Self guided and docent tours of Maynard Dixon's home and property are offered by the Thunderbird Foundation of the Arts, a 501(c)3 organization. Tours begin at the Thunderbird Foundation headquarters, located in the Gallery at 2200 South State Street in Mount Carmel. (www.thunderbirdfoundation.com)

Zane Grey Walking Tour
Kanab, Utah

Walking tour of the Purple Sage Inn where Zane Grey lodged in 1908; the E.D. Woolley home where Grey visited to learn the ways of the Mormon people; the Heritage House, home of a man who was the model for a villain in Grey's *Rainbow Trail*; and the Rocking V Cafe, a hardware store owned by Woolley during Grey's visit which outfitted his adventures roping cougars in the Grand Canyon.

Pipe Spring National Monument
15 miles west of Fredonia, Arizona on Arizona State Route 389

Windsor Castle at Pipe Spring National Monument is believed by many Zane Grey experts to be the inspiration for the Withersteen Ranch, a key location in Grey's novel, *Riders of the Purple Sage*. (www.nps.gov/pisp)

Lees Ferry and the Lonely Dell Ranch Historic Site
15 miles west of Fredonia, Arizona on Arizona State Route 389

Visit the inspiration for Zane Grey's first Western novel, *The Heritage of the Desert*. In 1907 and 1908, Grey stayed with the ferryman and owner of the ranch, Jim Emett. (www.nps.gov/glca/planyourvisit/lees-ferry.htm)

Maynard and Zane: Together at Last

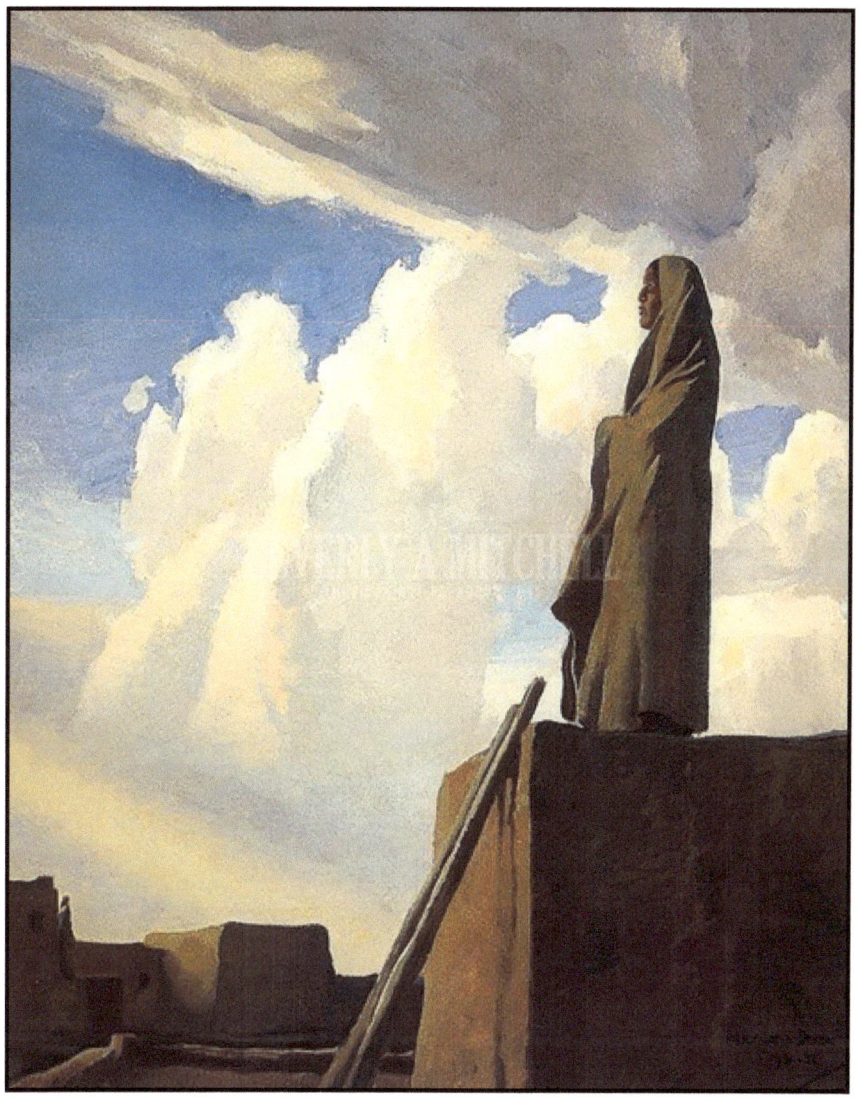

www.ingramcontent.com/pod-product-compliance
Lightning Source LLC
Chambersburg PA
CBHW040914180526
45159CB00010BA/3063